UNIVERSITY OF
GLOUCESTERSHIRE
at Cheltenham and Gloucester

Park Library
University of Gloucestershire
Park Campus, The Park, Cheltenham,
Gloucestershire GL50 2RH

The Six Fundamentals of Typographic Jurisprudence

I. Anatomy
 Stroke
 Body Parts
 Serif
 Terminal

II. Proportion
 Weight
 Width
 Staff
 X-Height
 Posture
 Axis
 Optics
 Counter

III. Technology
 Cast Metal Type
 Digital Type

IV. Metrics
 Sizing
 Spacing
 Measure

V. The Grid
 Module
 Column
 Margin
 Flowline

VI. Genealogy
 Type Family
 Type face
 Font
 Type Style
 Character

A A a

aaaaaaaaaaaaaaaaaaaaaaa

...It all began

a a *a* a **a** a a a a a **a** **a** a **a** a a

a long, long

α α α α a a a a a a a a a a a a a

time ago,

around 1440, in Europe, when an innovative goldsmith by
the name of Johannes Gutenberg developed the art of
printing with interchangeable, cast-metal type. By the end
of the 15th century, the European culture, already rich in
Romanesque and Gothic expression, was at the threshold of
a Renaissance. Scholars and printers began producing and
packaging knowledge once hidden from public consciousness.
They gave thousands access to the great works of Socrates,
Plato, Chaucer and others whose minds helped drive
intellectual development around the world. And it is here
where typography as we know it was born...

A TYPE
DETECTIVE STORY

A RotoVision Book
Published and Distributed by RotoVision SA
7 rue du Bugnon
1299 Crans
Switzerland

RotoVision SA Editorial & Sales Office
Sheridan House
112/116A Western Road
Hove, East Sussex
BN3 1DD England
Tel +44 1273 72 72 68
Fax +44 1273 72 72 69
Net sales@RotoVision.com

ISBN 2-88046-331-9

Production & Separations in Singapore
by ProVision Pte. Ltd.
Tel +65 334 7720
Fax +65 334 7721

Book design by

-IZATION

A TYPE DETECTIVE STORY

Episode One: The Crime Scene

Matthew Woolman

RotoVision

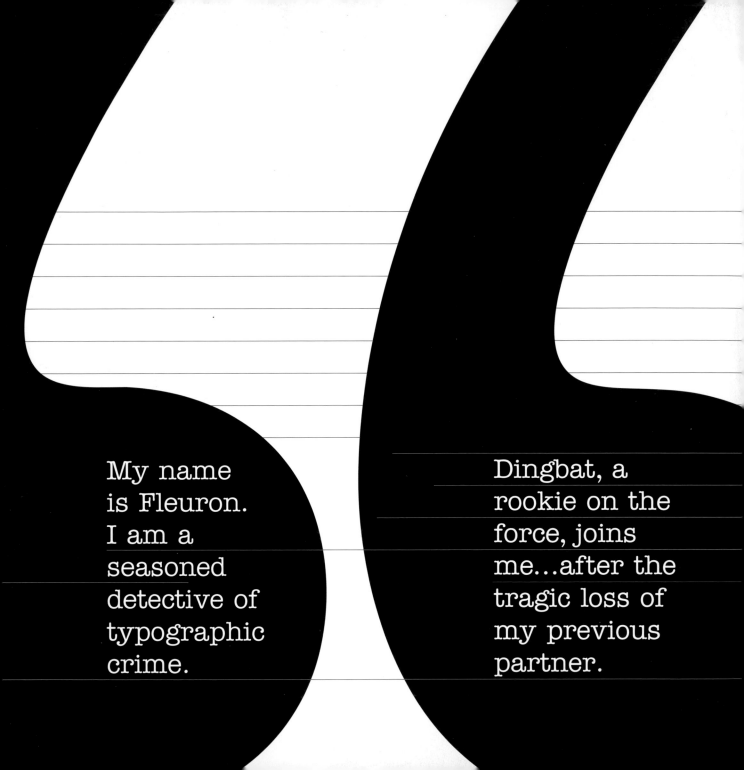

My name is Fleuron. I am a seasoned detective of typographic crime.

Dingbat, a rookie on the force, joins me...after the tragic loss of my previous partner.

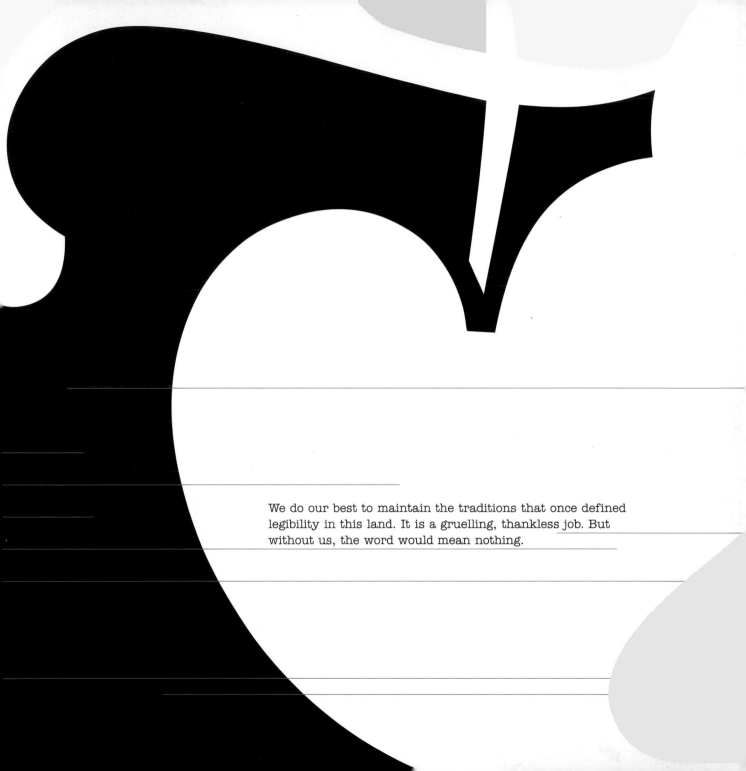

We do our best to maintain the traditions that once defined legibility in this land. It is a gruelling, thankless job. But without us, the word would mean nothing.

Our shift begins in a typical setting, under a moon that casts perfectly spaced shadows through the distinctive silhouette of the typescape...

The International Standards Organization, a.k.a. the ISO, dispatches us to the end of the baseline—a region known for its fragile state of legibility—to investigate a possible case of formal foul play.

As we enter the page, the familiar stench of wet ink announces the scene of yet another crime and carries an aftertaste of fear for the danger that awaits us.

We follow a trail of ink spots which leads us...

TREAD HERE!

into
a forest
of
question
marks!

A sliver of light pierces the forest canopy and reveals a lone character dangling from an empty line; stretched, fractured and twisted from all recognition. A drop shadow zooms into the pages beyond...

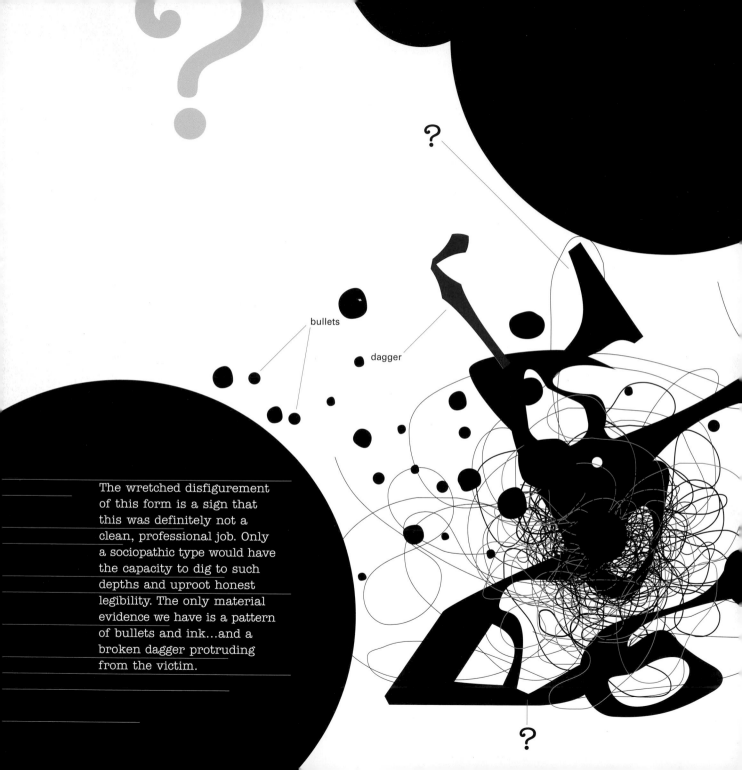

bullets

dagger

The wretched disfigurement of this form is a sign that this was definitely not a clean, professional job. Only a sociopathic type would have the capacity to dig to such depths and uproot honest legibility. The only material evidence we have is a pattern of bullets and ink...and a broken dagger protruding from the victim.

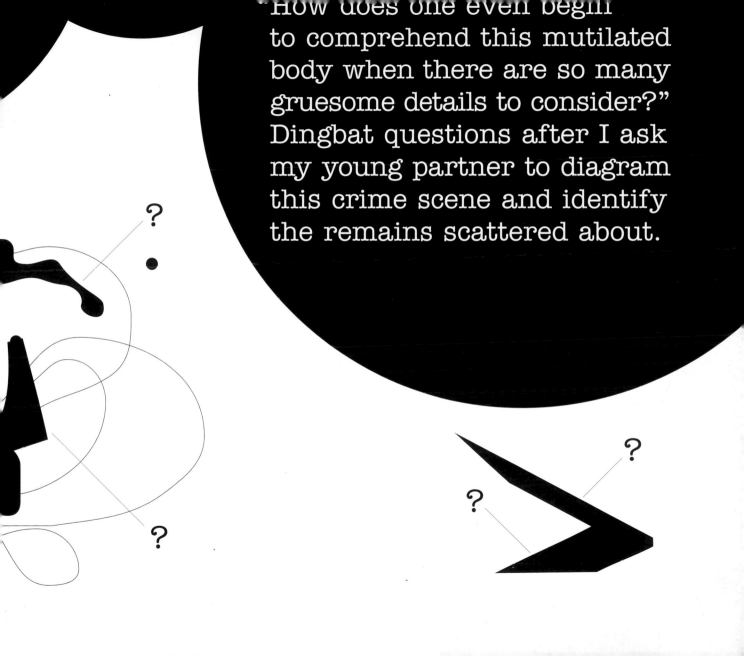

"How does one even begin to comprehend this mutilated body when there are so many gruesome details to consider?" Dingbat questions after I ask my young partner to diagram this crime scene and identify the remains scattered about.

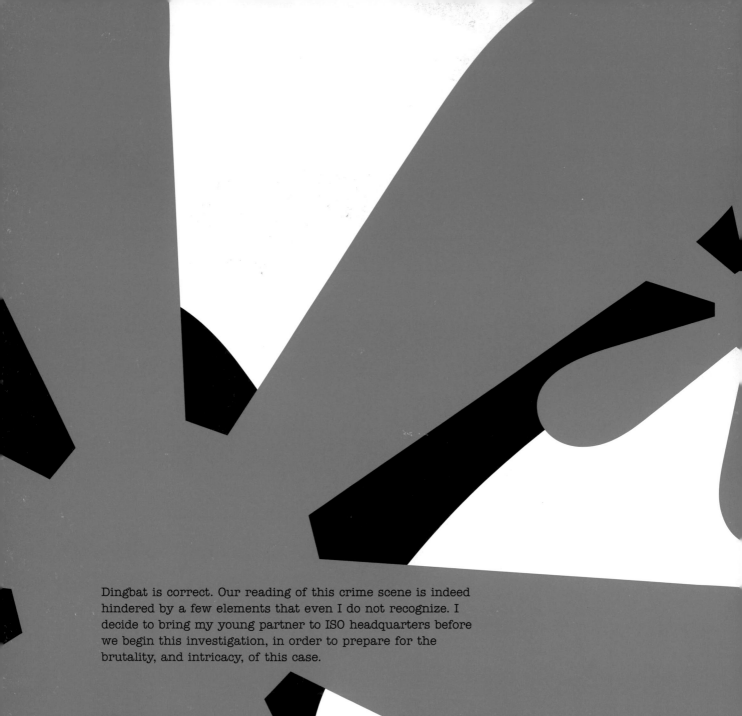

Dingbat is correct. Our reading of this crime scene is indeed
hindered by a few elements that even I do not recognize. I
decide to bring my young partner to ISO headquarters before
we begin this investigation, in order to prepare for the
brutality, and intricacy, of this case.

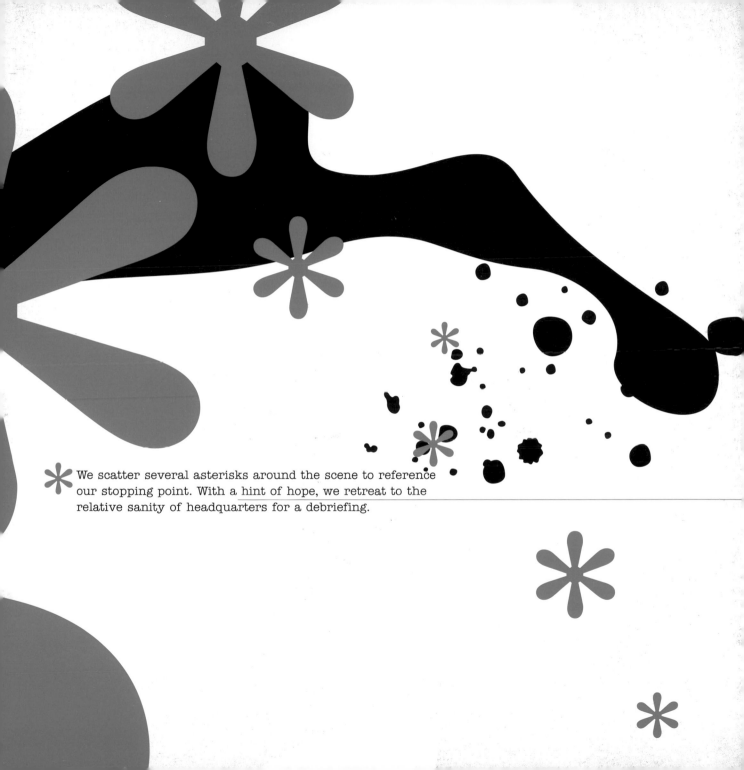

We scatter several asterisks around the scene to reference our stopping point. With a hint of hope, we retreat to the relative sanity of headquarters for a debriefing.

The International Standards Organization, based in Geneva, Switzerland, is an agency for international cooperation on industrial and scientific standards, including the utilitarian function of the alphabet and other characters. The ISO is composed of standards organizations located around the world.

abcdefghijklmnopqrstuvwxyz

ABCDEFGHIJKLMNOPQRSTUVWXYZ

$1234567890<[(.,""''-;:)]>\!@#$%^&*+-=?

I have been working out of the ISO for too many years now. Once upon a time, this job proved to be little more than style cop. My beat was to keep crowding letters evenly spaced and lines of type orderly and moving in a single left-to-right direction. And, occasionally, I would have to apprehend an unruly character to prevent unnecessary hindrances to communication.

Ever since the rise of digitization, instances of random chaos have increased. Consequently, my sense of legibility has been challenged. The entries into my investigator's handbook (from which you read) allow me the reassurance that I can serve a valuable role in this world of words. Oh, and please excuse the occasional digressive captions. They are mainly for the benefit of Dingbat, but you may find them helpful as well.

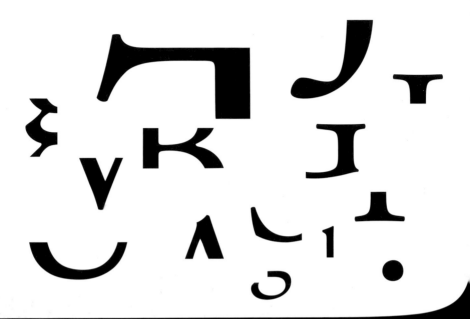

At ISO headquarters, we visit the top-secret Laboratory of Forensic Typography. This operation is a literary scrap heap of bits and pieces from all types. Here, detailed typographic knowledge is applied to legal matters. A high level of precision is important in this facility, where the outcome of a case can be determined by a factor as small as the width of a stroke.

"Are you certain I am allowed in there?" Dingbat quips upon seeing the typographic appendages piled outside a door that reads: "ONLY CHARACTERS OF SOUND BODY AND MIND BEYOND THIS POINT!"

Finding no humor in Dingbat's remark, I inform my young partner that an understanding of the SIX FUNDAMENTALS OF TYPOGRAPHIC JURISPRUDENCE is the key to a successful career in legibility enforcement. This begins with the first fundamental: ANATOMY.

The earliest form of writing involved pictographic symbols that represented ideas, complete words and syllabic sounds. The beginnings of the modern western alphabet can be traced to the Phoenician culture in southwest Asia as early as 1200 BC. The Phoenicians simplified pictographic symbols to represent individual spoken sounds. The original Phoenician alphabet consisted of 22 consonants and no vowels.

Industrial trade exposed the Greeks to the Phoenicians and their alphabet. Around 800 BC the Greeks adopted the Phoenician symbol system and translated the names of letters into their own tongue. The Greeks also added the vowel sounds of A, E, O, and U (which actually looked like a V until around 300 AD) to some of the existing consonants. The first two letters of the Greek system, "alpha" and "beta," combines to form the word "alphabet".

The Etruscans adopted and westernized the Greek alphabet in Italy around 500 BC. The Romans eventually adapted the Etruscan system to a left-to-right writing direction and refined the alphabetic skeleton to the basic inner structure that remains intact almost 2,000 years later.

The fundamental element of a letterform is the STROKE. Each modern western letterform evolved as a simple symbol whose visual characteristics distinguish it from the others. For example, the capital letter A is recognized as having two vertical strokes that converge at an angle to form a triangle that is intersected by a horizontal stroke.

The original western alphabet took on formal qualities through the use of various writing tools. In ancient Greece and Rome, letters were either cut into stone, or painted on a stone surface with a flat brush. Because of the limitations of the mallet and chisel, the early letterforms were constructed with very thin, straight lines and based on simple geometry that used little or no curves.

The letterform developed curvilinear and modulating strokes with the use of the flat brush in Imperial Rome. The flat brush was held at an angle to carefully trace a letterform onto stone that was eventually chiselled. The serif also appeared during this time as a way to formally end a stroke. This led to the development of the unical alphabet: A single set of letters that consisted of capital and lower case forms.

The alphabet reached its 26 letter peak, with the addition of an actual V as a separate letter from the U, in the Middle Ages. Lower case letters, also known as minuscules, along with many different letterform designs, also emerged with the use of the reed pen by scribes in medieval Christian monasteries. This highly flexible tool allowed the hand to freely render a stroke that alternated between thick and thin lines.

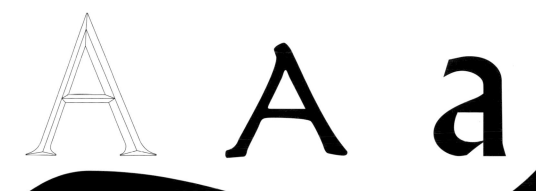

TYPOGRAPHY is the art and technique of creating and composing type in order to convey a message. The term TYPE includes the design and function of alphabetic and analphabetic symbols to represent language.

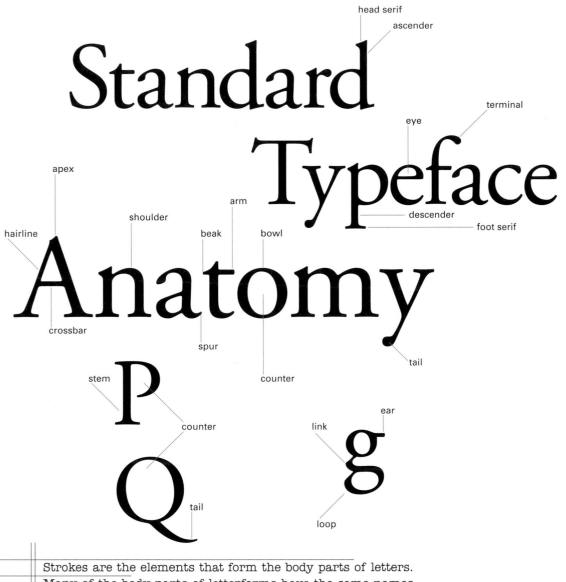

Standard Typeface Anatomy

head serif

ascender

terminal

eye

apex

arm

descender

foot serif

shoulder

beak

bowl

hairline

crossbar

spur

counter

tail

stem

counter

ear

link

g

loop

tail

Strokes are the elements that form the body parts of letters.
Many of the body parts of letterforms have the same names
as human body parts.

ceo at

bdpq ijru

hmntu

bdhkl

CDGOQ ()(((

AMVW ΛVV V

BEFHIKLPR]]]]]II]]]

BEF ʳ ʳ ʳ

BPR ᴅᴅᴅ

ELZ

Many healthy letterforms share the same parts. This helps in understanding the alphabet as a system of symbols. It also helps in reconstructing damaged characters, and transplanting appendages to other victims of typographic violence.

head serif

serif-stroke joint

sans (without) serif

dp dp

serif-stroke joint

foot serif

The serif most likely originated as a way to formally end a stroke in hand-drawn letters. When the broad-tipped quill pen finished a stroke, a slight pause produced an extra amount of ink that eventually developed into the serif. This visual characteristic was eventually designed into printing typefaces.

One of the main identifying characteristics of a letterform is the SERIF. This unassuming appendage has become a mark of dignity in what has devolved into a digitally-intoxicated, image-conscious, superficial world.

15th C. 16th C. 17th C.

Letterforms who proudly wear serifs can often be traced to the specific historic contexts from which they came.

joinery

The serif-stroke joinery is the intersection of a stroke with a serif. Generally, the joinery is either transitive, with a smooth transition, or abrupt, with a distinct corner angle.

transitive joint (fillet)

abrupt joint

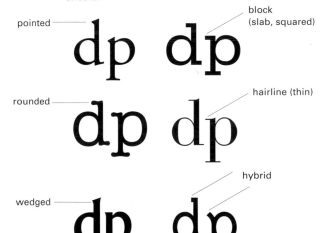

proportion

Serif proportion is the relationship of the serif to the stroke. Generally a serif will be bilateral: equally present on both sides of a stroke; or it may be unilateral: present on only one side of a stroke.

bilateral

unilateral

shape

Serif shape is the general shape of the serif. This is the main characteristic that can distinguish one type style from another.

pointed

block (slab, squared)

rounded

hairline (thin)

wedged

hybrid

angle

The serif angle refers to the angle, or pitch, of the serif. Generally, a serif either has a distinct angle in relation to the stroke, or is flat, or perpendicular, to the stroke.

oblique

flat

flat

18th C. 19th C. 20th C.

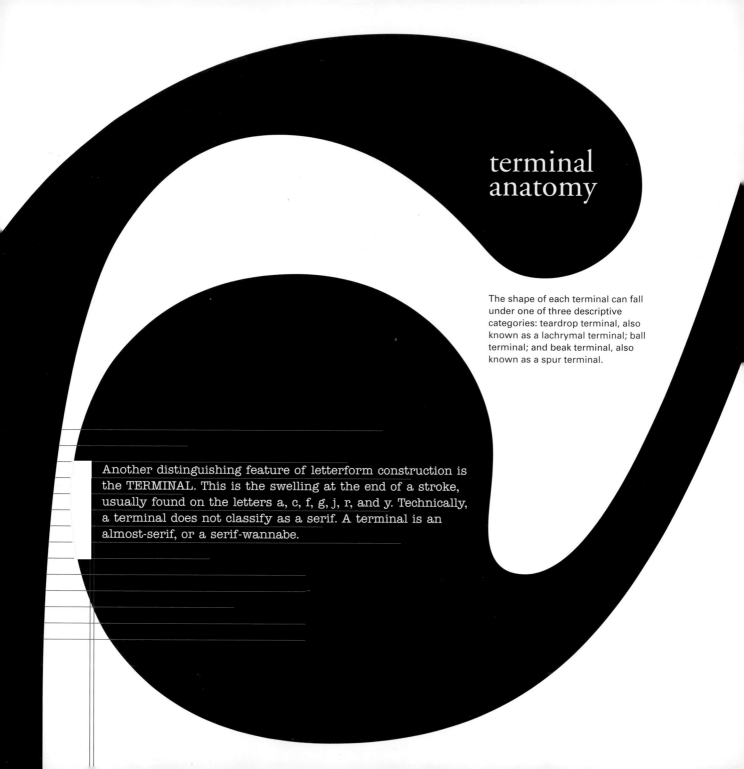

terminal
anatomy

The shape of each terminal can fall under one of three descriptive categories: teardrop terminal, also known as a lachrymal terminal; ball terminal; and beak terminal, also known as a spur terminal.

Another distinguishing feature of letterform construction is the TERMINAL. This is the swelling at the end of a stroke, usually found on the letters a, c, f, g, j, r, and y. Technically, a terminal does not classify as a serif. A terminal is an almost-serif, or a serif-wannabe.

acfgjry

teardrop/lachrymal
The teardrop terminal is shaped
like a droplet of water.

acfgjry

ball
The ball terminal has a
circular shape to it.

acfgjry

beak/spur
The beak terminal has a sharp,
angular shape at its tip.

usbimgauo

ambiguous

i s
u
a b u
m o
g

(the letters)

(the word)

(the idea)

Language is a flexible system. Letters are utilitarian symbols used to represent language and have no meaning until they are assembled into words.

A word is a sequence of symbols to which meaning is applied. In most cases a word does not look like the idea it represents.

Letters are at once representations of themselves and symbols for ideas when assembled into words and sentences.

"I beg your pardon, sir, if the alphabet has remained the same all these years, why is this word, 'legibility,' so important to us?"

True, the letter A has been the letter A for thousands of years...on the inside. But outside, appearances can say a lot about a character. The idea of legibility evolved with the past 550 years of printing and typeface design. This curious word does not have a precise definition, but it can be applied to the inherent visual and structural characteristics of a typeface: The physical qualities that give a typeface the ability to convey its symbolic meaning.

The idea of legibility evolved with the past 550 years of printing and typeface design. There are certain characteristics of the design of letters that facilitate their recognition as symbols for language.

legibility

LEGIBILITY

The top halves of letters are more recognizable than the bottom halves.

legibility

LEGIBILITY

The right halves of letters are more recognizable than the left halves.

legibility

LEGIBILITY

Thought and sound are shapeless and meaningless without language, Dingbat. The alphabet evolved as a system of simple symbols that have no meaning until they are arranged to form words. But letters have visual characteristics that make them objects before they serve any function. Typographic characters are building blocks that serve as both a linguistic utility and an expression of the alphabet.

The meaning generated by a collection of type depends on the context in which they exist. Therefore, what might be legible to one might not be to another. When approaching each typographic case, the WHO, the WHAT, the WHERE, the WHEN and the WHY must be considered. Now, I will show you why we have a job, Dingbat...

After the parts of victims are identified by the forensics experts, they make efforts to restore the characters to a functional condition. This is a highly controlled environment where each project is taken very seriously. The maintenance of legibility is of primary importance when approaching each new case, no matter how hideous the situation. Many forms re-enter full communication without any hindrance to legibility. Others are simply beyond repair, and are left as donors for other hapless victims of typographic crimes.

Severe crumpling and twisting of overall form.
The perpetrator was most likely big and strong.

Dislocated serifs.

Twisted mess consists of body
parts, ink and grid matter.

Straight lines connected
at sharp angles.

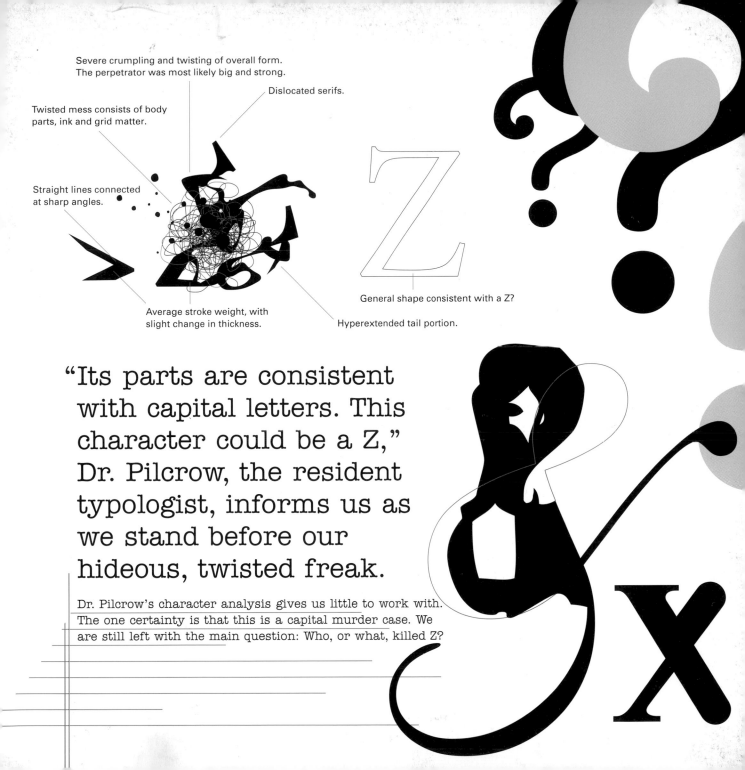

General shape consistent with a Z?

Average stroke weight, with
slight change in thickness.

Hyperextended tail portion.

"Its parts are consistent with capital letters. This character could be a Z," Dr. Pilcrow, the resident typologist, informs us as we stand before our hideous, twisted freak.

Dr. Pilcrow's character analysis gives us little to work with. The one certainty is that this is a capital murder case. We are still left with the main question: Who, or what, killed Z?

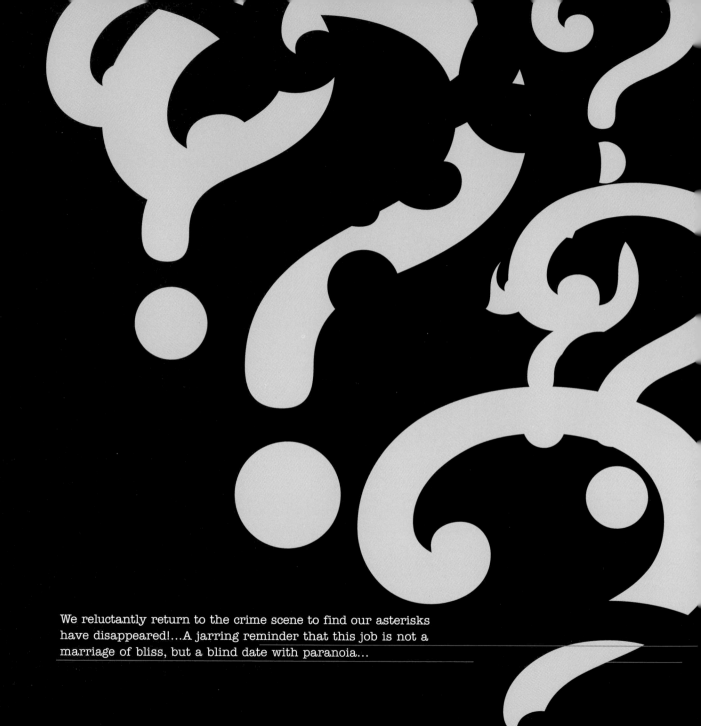

We reluctantly return to the crime scene to find our asterisks
have disappeared!...A jarring reminder that this job is not a
marriage of bliss, but a blind date with paranoia...

Suddenly a swarm of killer ee's emerges from a partially hidden ee-hive!

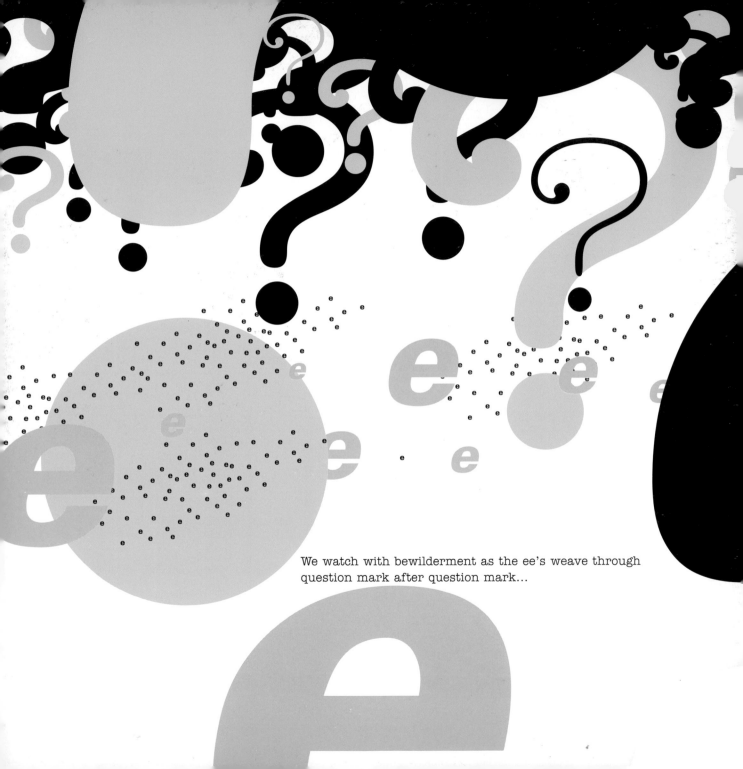

We watch with bewilderment as the ee's weave through question mark after question mark...

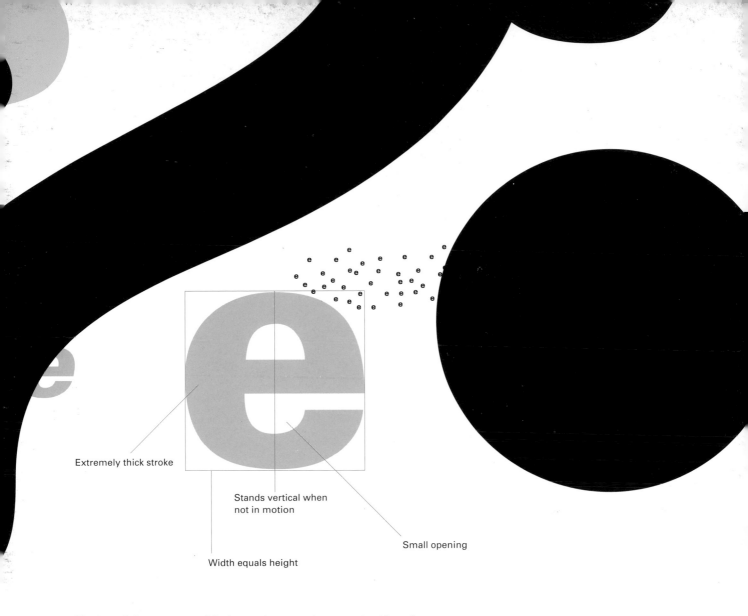

Extremely thick stroke

Stands vertical when
not in motion

Small opening

Width equals height

Fortunately, we are able to capture a stray ee inside a box
for questioning. But a closer examination requires us to
review the second fundamental of typographic jurisprudence:
PROPORTION.

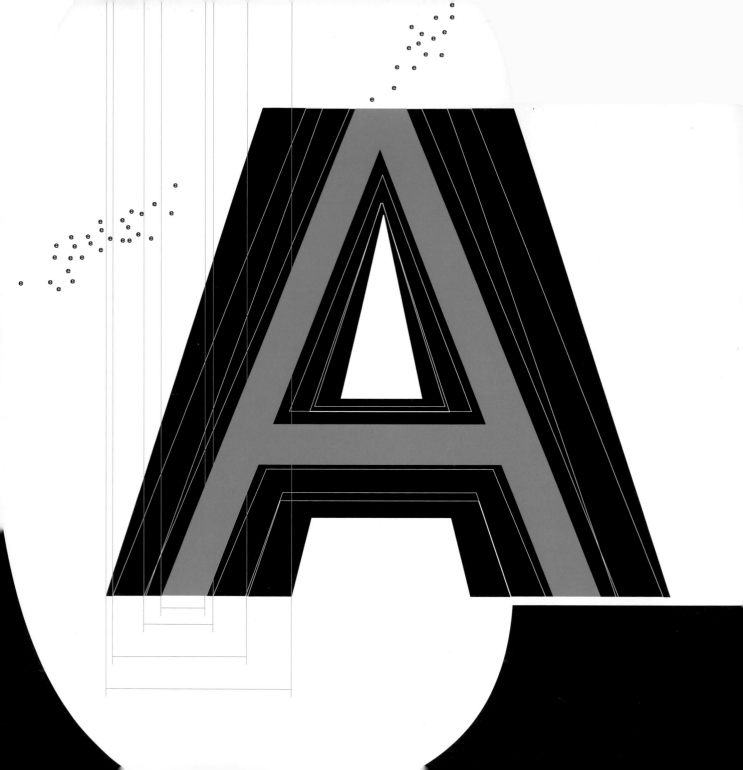

WEIGHT

Garamond Family

e **e**

regular · bold

The blackness or heaviness of a character is referred to as its weight. The weight of a character is determined by the relationship of the thickness of its stroke to its overall height. Traditionally, a typeface is designed with at least two weights: regular and bold.

Univers Family

e e **e** e **e**

thin · regular · bold · black · extra black

Helvetica Family

e e e e e **e e e**

ultra light · thin · light · roman · medium · bold · heavy · black

Typographic characters come in many proportions: short and wide; tall and thin; big and fat; small and skinny. The ee we captured is definitely on the heavy end of the weight scale. This swarm must have eaten recently, which puts us in a safe position. You'll find all types out there, I warn Dingbat. Never judge a character by its weight, but you always have to be cautious of its behavior. These are fat killer ee's, and they were flying a little too close to the crime scene to be completely innocent!

WIDTH ??

Univers Family

e ultra condensed thin e ultra condensed light e ultra condensed regular e condensed regular e regular

Myriad Family

e regular condensed e regular normal e regular semi-extended

The width of a character is determined by the interval of space between its vertical strokes and counters. Common terms describing widths include condensed, regular, extended.

Helvetica Family

e ultra compressed e extra compressed e regular compressed e condensed regular e narrow regular

"I beg your pardon, Inspector Fleuron, but is there a standard means to determine the proportions of a character?"

Unfortunately, there is no standardization of weight and width ratios in typography. They are relative measures that depend on the design of a specific typeface. When in doubt about the innocence of a character, a lineup of possible suspects is always helpful...

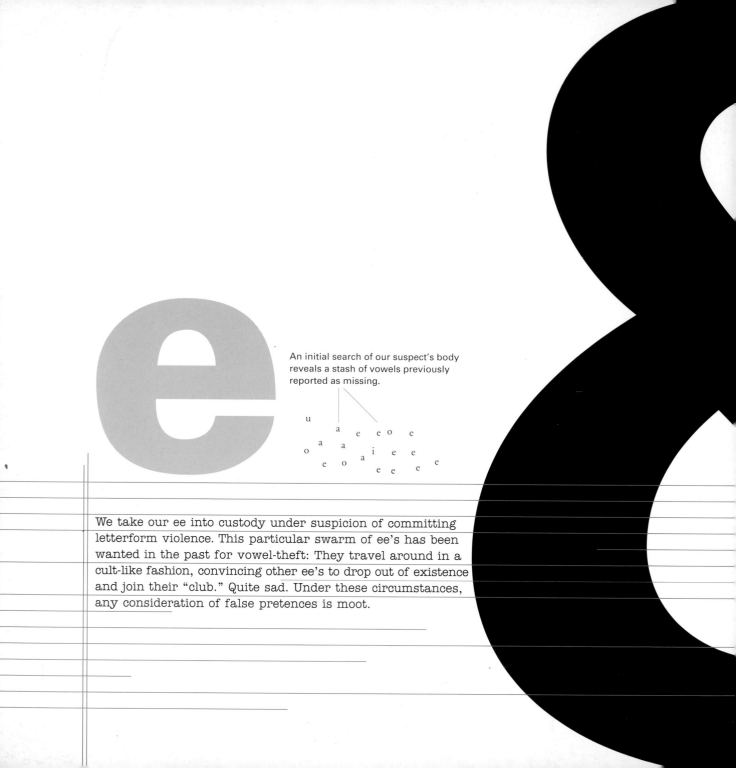

An initial search of our suspect's body reveals a stash of vowels previously reported as missing.

We take our ee into custody under suspicion of committing letterform violence. This particular swarm of ee's has been wanted in the past for vowel-theft: They travel around in a cult-like fashion, convincing other ee's to drop out of existence and join their "club." Quite sad. Under these circumstances, any consideration of false pretences is moot.

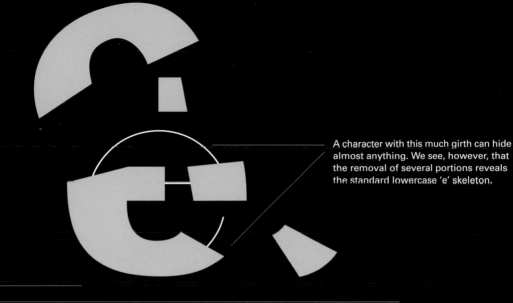

A character with this much girth can hide almost anything. We see, however, that the removal of several portions reveals the standard lowercase 'e' skeleton.

Upon arrival at ISO headquarters, suspects are strip-searched to reveal any hidden motives. This can be a humiliating experience for the character involved. But if you take these types at their face value, you only see part of the picture. You have to place them into a context—the scene of the crime—in order to gain the full meaning. This relates to the who, what, where, when and why questions.

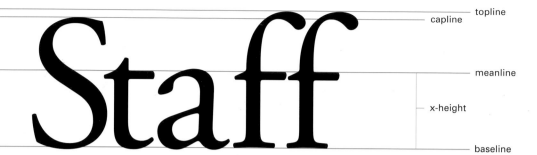

topline

capline

meanline

x-height

baseline

beardline

The staff is made of four main
components: beardline, baseline,
meanline and capline.

Typographic characters have an inherent gravity. They are
most comfortable standing upright on firm ground. This is
the way they evolved. The lineup takes place on the STAFF,
which is an imaginary system of guidelines used to align
letters evenly in sequence.

x-height

The x-height is the distance between the baseline and meanline of the lowercase character, minus the ascender and descender. The x-height varies in proportion with the ascender height and descender depth in different typefaces.

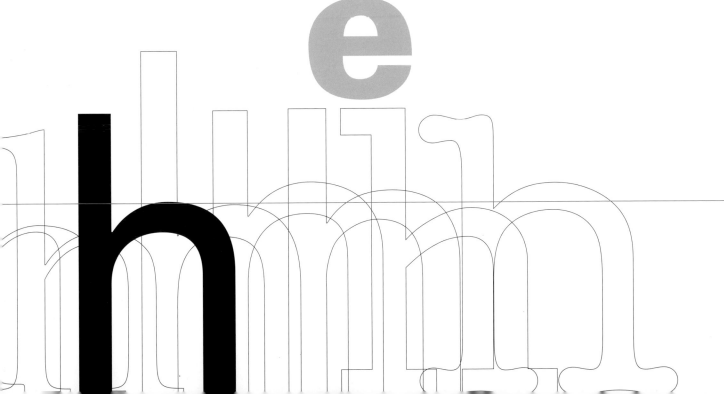

posture

eeeeee

0° 2° 10° 12° 24°

The angle of incline is known as the
slope, or slant, and usually ranges
between 2° and 24° from vertical. A
slope of 10° to 12° is considered normal.

The lineup also allows a character's posture to be evaluated.
Those types that slope to the right are most likely running
from something and they tend to draw attention to
themselves. They should be watched closely.

The Roman-refined alphabet consisted of vertically upright and stiff letters until the 15th century. In 1498, A scholar and printer named Aldus Manutius opened a press in Venice to print Greek and Latin texts in several languages including Italian, French and Latin, but felt too limited by the vertically-oriented letters of the Roman alphabet.

Roman

The standard, upright, posture of a character is known as roman because it emerged from the alphabet refined by the Romans.

In 1499, Aldus commissioned a typefounder named Francesco Griffo to create a typeface that resembled cursive handwriting, in order to print letters closer together and to fit more words on a page. Griffo produced what became the first italic letters.

Italic

Characters that slant to the right and are different in structure from roman forms are known as italic. The original italic forms were developed to be distinct from, yet complementary to, their roman counterparts in the same typeface.

Characters that slant to the right but resemble roman characters in structure are known as oblique, or sloped roman, or artificial italic. Typefaces that are not blessed with an italic counterpart can most likely be obliqued, giving them a drunk-like appearance.

Roman
Oblique

Axis

The variation of stroke width in a letterform evolved from the use of the broadnib pen in handwriting.

By definition, an axis is an imaginary straight line that defines the center of a body or geometric object, and is the centris around which this object may rotate.

The axis also serves as the line by which an object is symmetrical on a flat plane.

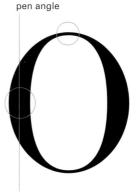

pen angle

The relationship of the thick to the thin of a stroke is known as stress, or contrast, and determines the axis of a letter. The angle of the axis corresponds with the thickest portion of the character's stroke, which corresponds to the angle of the writing instrument used to render the entire form.

One can detect a character's stress level by observing the variation of thickness in its strokes. Some characters are naturally more stressed than others, which makes it difficult to assess guilt.

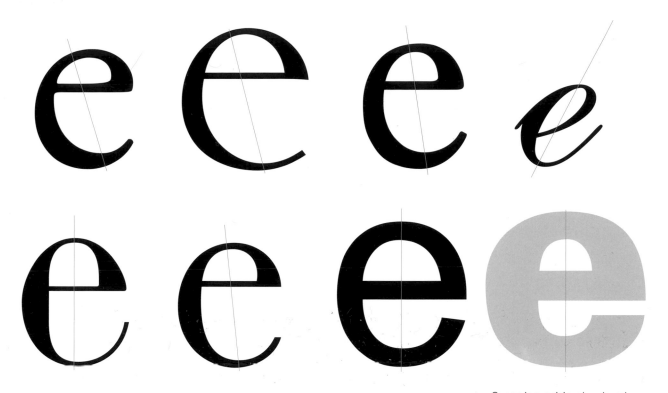

axis slope

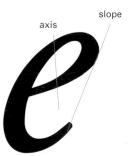

The axis of a character may be different
from its overall shape and slope.

Optics

Letterforms defined by pointed, curved
and vertical strokes appear shorter due
to little weight at the top and bottom
measure lines. In these forms, tips,
apexes and curves extend slightly above
top lines, and apexes and curves extend
slightly below baselines to allow these
letters to appear same size as forms that
end flush top and bottom.

AVOE

The consistent alignment of letters to the staff require certain
optical adjustments to the overall design and stress of each
character. Any character without these subtle refinements is
most likely an imposter and should be treated with suspicion.

The top half of regular capitals and figures often appears too large if the form is divided equally in the horizontal center. To achieve balance, the horizontal center is slightly higher, leaving the top halves slightly narrower than bottom.

BEHKSX38

Horizontal strokes have a tendency to appear too thick if they are the same weight as the vertical strokes in the same form. In most cases, the horizontal strokes are slightly thinner than vertical strokes, in curved and straight letterforms, in order to achieve a weight balance.

HTFE
HTFE

Curved strokes are usually thicker in the midsection than vertical strokes in order to achieve an even appearance.

BDOPQ
BDOPQ

Tight or angled stroke junctions open slightly to prevent the appearance of thickening at the joint.

KMNXY

The stroke ends of letterforms with strong diagonal and vertical strokes taper slightly to open up counter spaces.

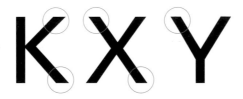

K X Y

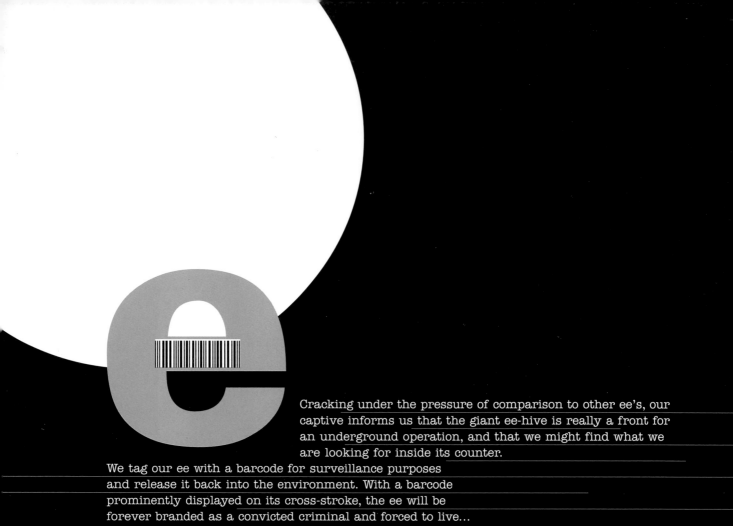

Cracking under the pressure of comparison to other ee's, our
captive informs us that the giant ee-hive is really a front for
an underground operation, and that we might find what we
are looking for inside its counter.

We tag our ee with a barcode for surveillance purposes
and release it back into the environment. With a barcode
prominently displayed on its cross-stroke, the ee will be
forever branded as a convicted criminal and forced to live...

a life in hiding...

counter

The counter is the space created by a closed, or partially closed, stroke. The counter is considered a form in itself that can be large or small in relation to the overall weight and width of a letterform. The size of a character's counter is referred to as the aperture, and is described in terms of small, medium and large.

large aperture small aperture

We return to the ee-hive entrance. The opening is small, but we manage to squeeze through...

A chill seeps into my form as we enter the darkened space.
A rustling on the next page leaves us with the feeling that
we are being watched....or read! The question is: By whom...

or what?

The scene around us suddenly reveals crude forms huddled
along a dark corridor, illuminated by a phosphorescent
orange backdrop...Sure enough we have entered some kind
of digital underworld!

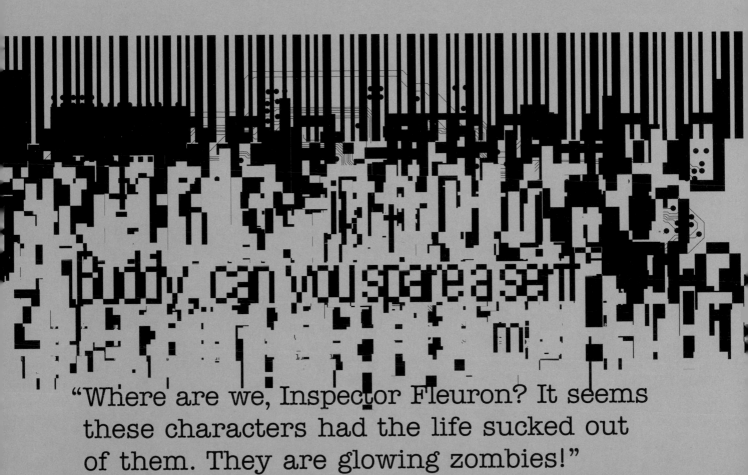

"Where are we, Inspector Fleuron? It seems these characters had the life sucked out of them. They are glowing zombies!" Dingbat asks with a touch of nervousness.

The characters here seem to have been stripped of all distinguishing marks and left in a state of typographic poverty...

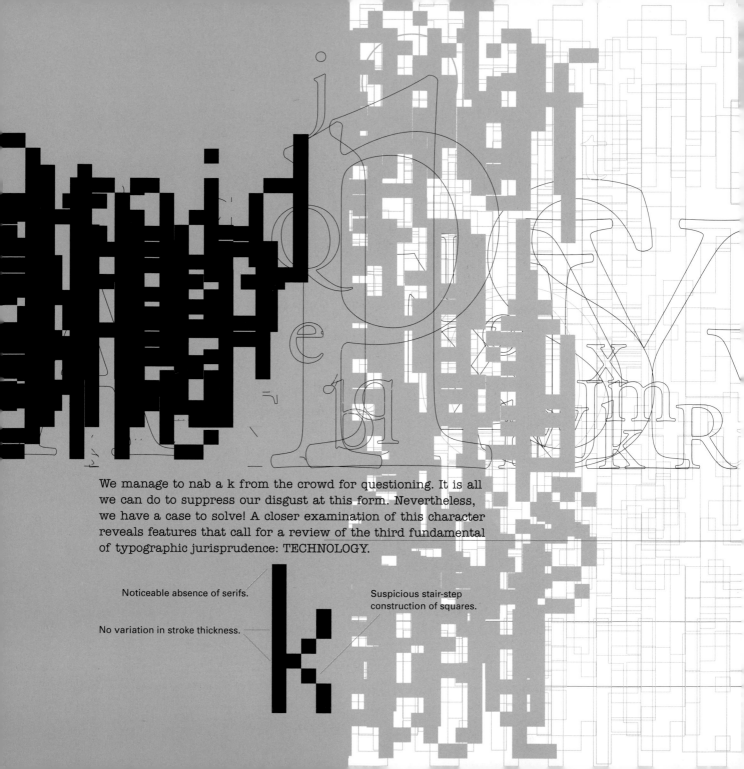

We manage to nab a k from the crowd for questioning. It is all we can do to suppress our disgust at this form. Nevertheless, we have a case to solve! A closer examination of this character reveals features that call for a review of the third fundamental of typographic jurisprudence: TECHNOLOGY.

Noticeable absence of serifs.

Suspicious stair-step construction of squares.

No variation in stroke thickness.

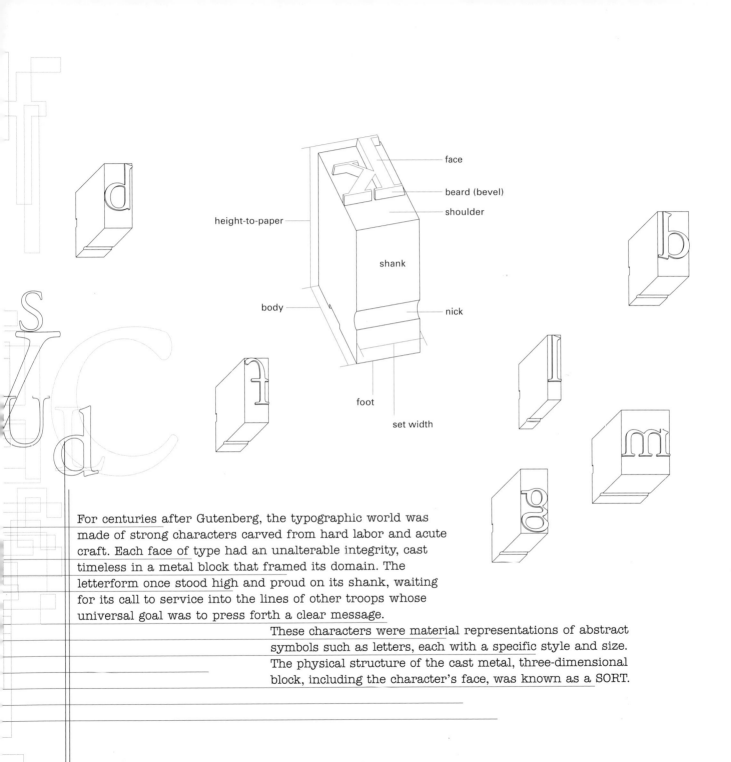

face

beard (bevel)

shoulder

height-to-paper

shank

body

nick

foot

set width

For centuries after Gutenberg, the typographic world was
made of strong characters carved from hard labor and acute
craft. Each face of type had an unalterable integrity, cast
timeless in a metal block that framed its domain. The
letterform once stood high and proud on its shank, waiting
for its call to service into the lines of other troops whose
universal goal was to press forth a clear message.

These characters were material representations of abstract
symbols such as letters, each with a specific style and size.
The physical structure of the cast metal, three-dimensional
block, including the character's face, was known as a SORT.

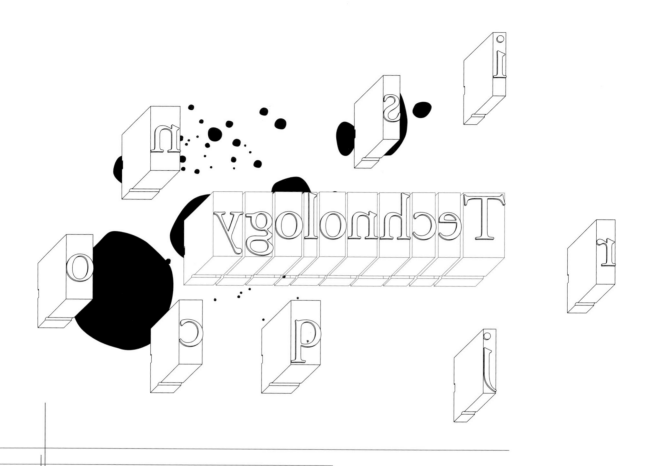

Letter by letter, line by line, the characters came together on
a device known as a COMPOSING STICK. Once the letters
were arranged in a desired, functional order, they were
transferred and locked into a rectangular steel frame called
a CHASE. The chase was placed on the letterpress where the
characters would perform their service.

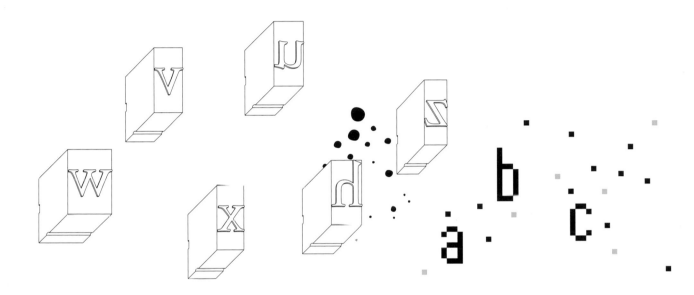

By the late 20th century the hard consistency of form had completely degenerated into a collection of illuminated dots that are as malleable as a lump of soft clay...

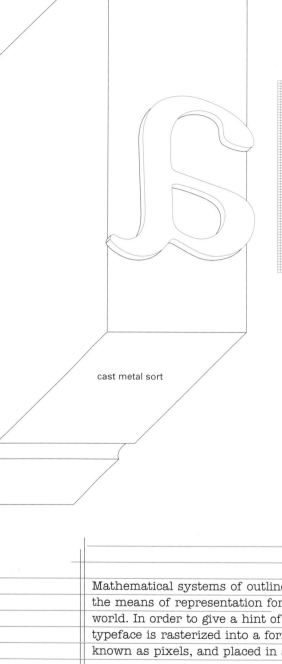

cast metal sort

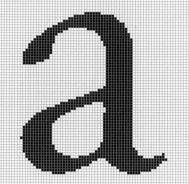

In order to render a letterform for computer screen display, the character must be rasterized, or converted into tiny dots known as pixels, short for picture elements. This process takes place on a bitmap matrix that contains 72 pixels per 1 inch, which is the average display resolution of a computer monitor. This also corresponds to the point system for measuring type.

a a a a a
72pt 36pt 24pt 18pt 12pt

The process known as hinting allows the computer to render a specific typeface accurately at different sizes when displayed at low resolutions.

72 pixels (dots)

The bitmap matrix is measured in dots per inch (dpi). The dot, also known as a pixel, is the smallest visible element displayed on a computer monitor.

Mathematical systems of outlines and templates now provide the means of representation for the typeface in this digital world. In order to give a hint of life on a computer screen, the typeface is rasterized into a form made of illuminated dots known as pixels, and placed in a pattern known as a bitmap.

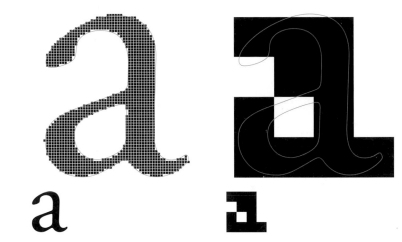

The computer uses an outline construction to precisely match the original type design for printing. This allows the printer to render a letter with smooth curves and angles, instead of the jagged, or aliased, construction of pixels.

When the computer cannot render a character properly on the screen, or if a printer cannot print a character as it should appear, the result is oftentimes a disastrous sacrifice of legibility. This condition is known as jaggies—an affliction that renders the smooth curve or angle of a character into a horrid stair-stepped pattern.

When a typeface is used strictly for screen display, the computer can reduce the jagged effect of the bitmapped image by averaging the color density of pixels at the edges of the image with the background. This technique, known as anti-aliasing, gives the hard, stair-stepped, edge a soft appearance that simulates a smooth contour.

Typefaces are no longer material objects. They have been reduced to mere concepts that have no physical existence until printed. The bitmapped representation of a typeface—its stylistic essence—is but a phantom of the past, rendered vulnerable in the hands of the insane...

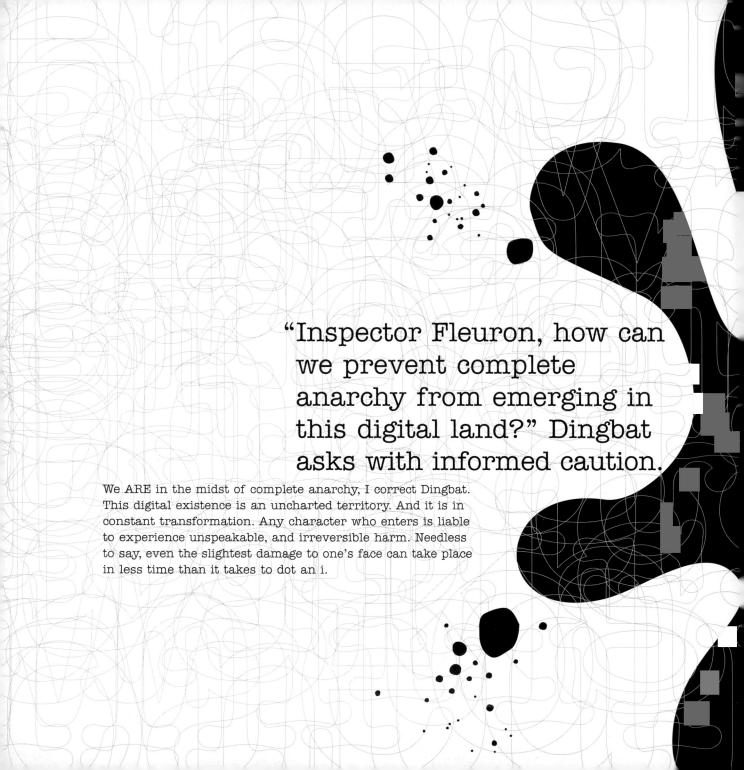

"Inspector Fleuron, how can we prevent complete anarchy from emerging in this digital land?" Dingbat asks with informed caution.

We ARE in the midst of complete anarchy, I correct Dingbat. This digital existence is an uncharted territory. And it is in constant transformation. Any character who enters is liable to experience unspeakable, and irreversible harm. Needless to say, even the slightest damage to one's face can take place in less time than it takes to dot an i.

This land is crawling with fugitives and deadbeat forms. None of these characters acts alone. Each represents a larger gang that constantly fights for attention and power. And in this process the innocent become victims, and decent communication is irreparably damaged.

Long ago, the humans developed mechanisms to aid in keeping characters in proper order. These devices are collectively known as typographic METRICS and represent the fourth fundamental. It is here where the parts come together, one character at a time, into a larger, meaningful whole.

typographic

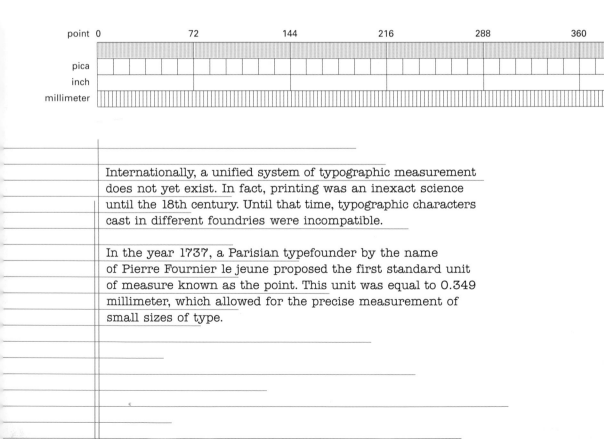

point	0	72	144	216	288	360	432
pica							
inch							
millimeter							

Internationally, a unified system of typographic measurement
does not yet exist. In fact, printing was an inexact science
until the 18th century. Until that time, typographic characters
cast in different foundries were incompatible.

In the year 1737, a Parisian typefounder by the name
of Pierre Fournier le jeune proposed the first standard unit
of measure known as the point. This unit was equal to 0.349
millimeter, which allowed for the precise measurement of
small sizes of type.

metrics

British-American Point System (Pierre Fournier le jeune)
smallest whole unit = 1 point (0.349 mm)
12 points = 1 Pica

Didot Point System (François-Ambrose "Firmin" Didot)
smallest whole unit = 1 point (0.376 mm)
12 points = 1 Cicero (Germany, Austria and Switzerland)
 = 1 Douze (France)
 = 1 Riga Tipografica (Italy)
 = 1 Augustijn (The Netherlands)

Metric System
smallest whole unit = 1 millimeter (mm)
1 mm = 2.85 points (pt)
10 mm = 1 centimeter (cm)
100 mm = 10 cm = 1 decimeter (dm)
1000 mm = 100 cm = 10 dm = 1 meter (m)

Inch System
smallest whole unit = 1 inch
1 inch = 72 points
12 inches = 1 foot
3 feet = 1 yard

Eventually, in 1886, the American Type Founders' Association standardized the point to 0.3515 millimeter. This new unit was adopted in America and Britain as the standard unit of measure. To make things more confusing, about 40 years later, a larger point was invented by Firmin Didot. His unit was equal to 0.376 millimeter and was adopted by the rest of continental Europe.

Since digitization, the point has been rounded off to 72 per inch, to make things more simple, and to match the 72 dots per inch resolution of a computer display monitor. However, Europe now uses the millimeter as the standard for measuring type.

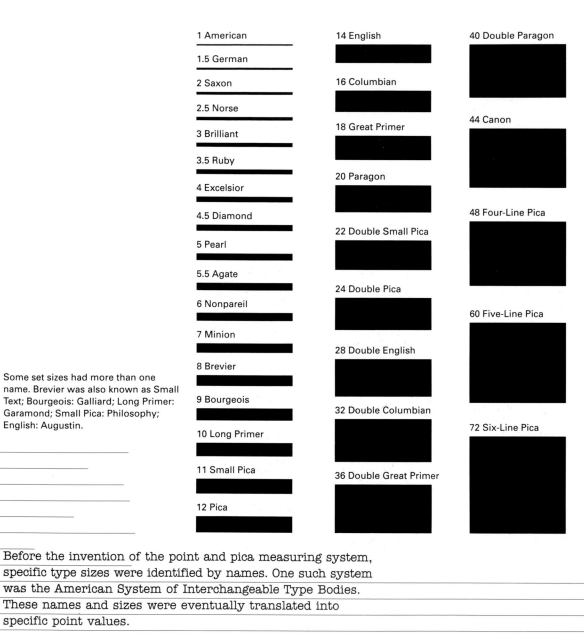

1 American

1.5 German

2 Saxon

2.5 Norse

3 Brilliant

3.5 Ruby

4 Excelsior

4.5 Diamond

5 Pearl

5.5 Agate

6 Nonpareil

7 Minion

8 Brevier

9 Bourgeois

10 Long Primer

11 Small Pica

12 Pica

14 English

16 Columbian

18 Great Primer

20 Paragon

22 Double Small Pica

24 Double Pica

28 Double English

32 Double Columbian

36 Double Great Primer

40 Double Paragon

44 Canon

48 Four-Line Pica

60 Five-Line Pica

72 Six-Line Pica

Some set sizes had more than one name. Brevier was also known as Small Text; Bourgeois: Galliard; Long Primer: Garamond; Small Pica: Philosophy; English: Augustin.

Before the invention of the point and pica measuring system, specific type sizes were identified by names. One such system was the American System of Interchangeable Type Bodies. These names and sizes were eventually translated into specific point values.

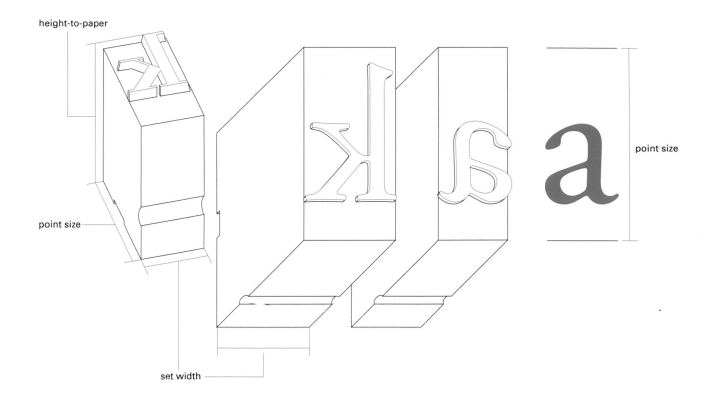

height-to-paper

point size

set width

point size

In order to achieve a uniform impression of ink onto paper, metal characters were cast with the same height. This was known as the height-to-paper, or typehigh and was equivalent to .918 inch.

The width of a metal character is known as the set width and is determined by the specific character represented. The capital letters M and W have the widest set width, and the letters i and l have the narrowest.

The size of a character was originally determined by the size of the three-dimensional block on which the face of type was cast, rather than the character itself.

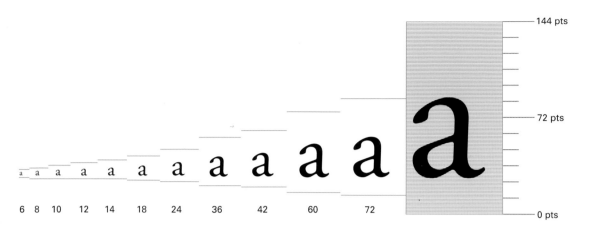

6	8	10	12	14	18	24	36	42	60	72

These standard point sizes are derived from cast metal type. Sizes other than the standard are known as bastard sizes.

144 pts

72 pts

0 pts

Digital Point Size

Text Type	Text Type	Text Type	Display Type	Display Type	Display Type
8 points	10 points	12 points	14 points	18 points	24 points

Traditionally, type that is set below 12 points is considered text type.

Type that is set above 12 points is considered display type and is used for headlines, signage and other contexts where large type is necessary.

In this digital land, the measurement of type is based on the three-dimensional characteristics of cast metal sorts. The point size of a digital typeface is determined by the highest ascender and the lowest descender of the typeface.

The pathetic, malnourished k we pulled aside for questioning
gives us information in exchange for a new set of serifs.

The silence that remains after k's departure is suddenly
interrupted by the cold steady drizzle of an electrified guitar.
Pulsating bass currents begin drifting from the next page...

Lost in the cacophony of flashing lights and sound, we trip over the bright red missing dagger piece!

The place k spoke of turns out to be a refuge for the
typographically corrupt. Many characters end up here, with no
where else to function. The not so lucky ones have fallen into
the gutter in a failed attempt to flee to the clean, white safety
of another page. Those who remain standing crowd together in
blatant disregard towards one another's space, searching
desperately for a place to fit in...

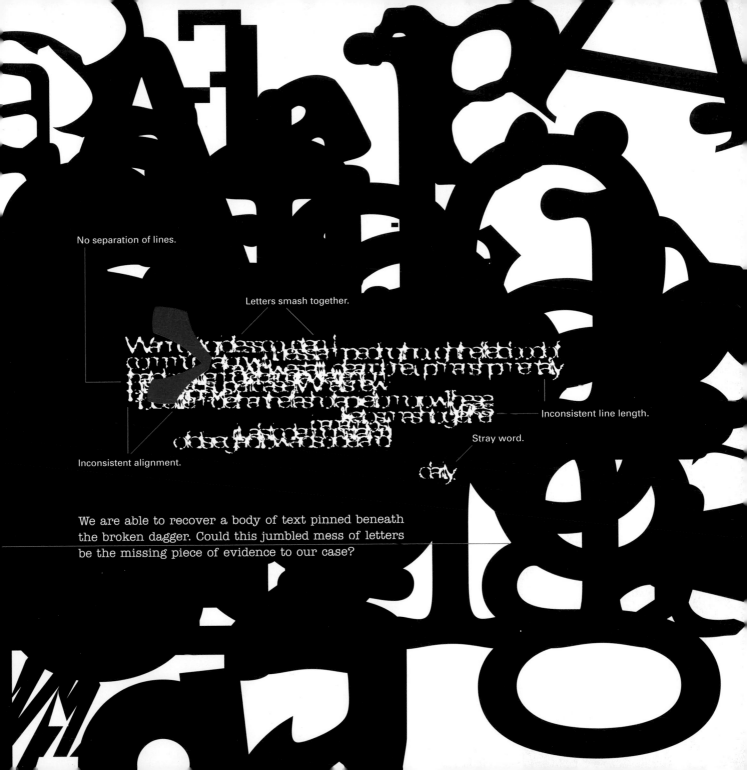

No separation of lines.

Letters smash together.

Inconsistent line length.

Stray word.

Inconsistent alignment.

We are able to recover a body of text pinned beneath the broken dagger. Could this jumbled mess of letters be the missing piece of evidence to our case?

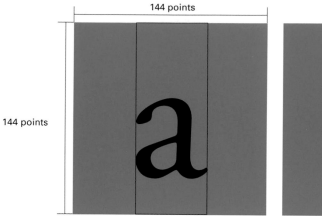

144 points

144 points

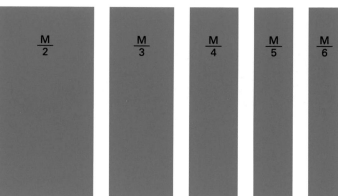

$$\frac{M}{2}$$ $$\frac{M}{3}$$ $$\frac{M}{4}$$ $$\frac{M}{5}$$ $$\frac{M}{6}$$

Each letter of the modern western alphabet has a width determined by its inherent structure. Because of this, letters are assembled into words with what is known as differential spacing. This is the spacing of each letter according to its individual width.

An em-quad is equal to the square of the point size of a letterform. The em is the widest single spacing unit of a typeface.

An en is equal to half the em of a typeface. The en is also known as two-to-em which means two of these units equal one em. Other increments include Three-to-em, also known as thick space or M/3; four-to-em, also known as middle space or M/4; five-to-em, also known as thin space or M/5; six-to-em, also known as hair space or M/6.

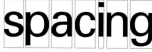

differential spacing

s p a c i n g

mono spacing

Back in the day, we had to enforce certain laws in keeping characters in line. If a single character slipped in any direction, it was sent to ISO for rehabilitation.

The body of text that we found has considerable spacing problems, so we send it to the Forensics lab for repair.

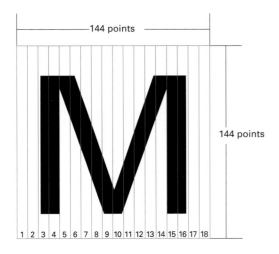

144 points

144 points

1 | 2 | 3 | 4 | 5 | 6 | 7 | 8 | 9 | 10 | 11 | 12 | 13 | 14 | 15 | 16 | 17 | 18

In 1887, Tolbert Lanston invented the unit system of measure in order to allow greater precision in adjusting the spacing between letters and words. Like the em-quad, the unit is a relative width system that changes in proportion to the typeface and its point size.

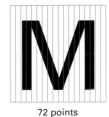
72 points

36 points

18 points

The unit is determined by the em-quad of a typeface. The unit value of a specific typeface was originally established by dividing the em-quad into 18 vertical segments. Since the onset of digitization, units in increments of 16, 36, 72 and even 1000 are used.

| 11 | 8 | 9 | 11 | 9 | 3 | 6 |

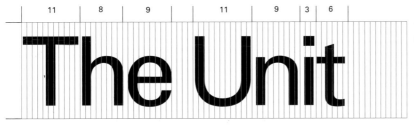

The letter and its surrounding space always occupies a whole number of units.

Tracking

In moveable typesetting, interletter spacing was adjusted by inserting thin brass strips between each pair of letters.

tight **Tracking**

normal **Tracking**

loose **T r a c k i n g**

Tracking is adjusted in increments of points, units or em-quad percentage. But it is generally specified in these general terms: tight, normal, loose (or open). Very loose and very tight are also used.

Tracking applies to the uniform space adjustment of the letters in an entire word, sentence, paragraph or larger text block. One can never track a single character without effecting the others around it.

In computer typesetting, the unit is used to adjust tracking in small increments.

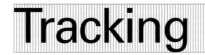

No tracking adjustment

Tracking adjusted -5 units.

Tracking

Tracking adjusted -10 units

Sans serif and condensed lowercase type is traditionally set with normal to tight tracking. This text block is set with -3 units to make its letters tight.

Tracking should not be confused with kerning. Kerning applies to the space relationship between two specific characters. Tracking applies to the uniform spacing of an entire word, sentence, paragraph or larger block of text.

Serifed, lowercase type is traditionally set with normal to loose tracking. This text block is set with normal tracking.

Tracking should not be confused with kerning. Kerning applies to the space relationship between two specific characters. Tracking applies to the uniform spacing of an entire word, sentence, paragraph or larger block of text.

Type set in all capitals should have normal to loose tracking. This text block is set with +5 units of tracking.

TRACKING SHOULD NOT BE CONFUSED WITH KERNING. KERNING APPLIES TO THE SPACE RELATIONSHIP BETWEEN TWO SPECIFIC CHARACTERS. TRACKING APPLIES TO THE UNIFORM SPACING OF AN ENTIRE WORD, SENTENCE, PARAGRAPH OR LARGER BLOCK OF TEXT.

There are certain procedures for tracking, depending on which, and how many, characters are involved.

Kerning

In moveable typesetting, notches were cut out of the metal blocks to allow letters to fit closely.

before kern	after kern		before kern	after kern	
AT	AT	AT	Va	Va	Va
AY	AY	AY	Tr	Tr	Tr
AV	AV	AV	To	To	To
AW	AW	AW	Ya	Ya	Ya
Ay	Ay	Ay	Yo	Yo	Yo
PA	PA	PA	Ly	Ly	Ly
WA	WA	WA			
YA	YA	YA			

Certain letters create awkward spacing when paired with one another. For example, letters with long horizontal strokes (such as T) and dominant, angled strokes (such as A, V, W, Y) contain more space in their zones than the other letters.

The "Kern Zone"

In moveable typesetting, each face was cast on a metal block with its own horizontal space known as the set width. The surface of this zone was known as the shoulder because it contained the face: a character's identity. In most cases, when two letters are placed next to one another, the set widths of the respective faces allow the characters to fit close enough to be considered part of a word. There are some instances in which the space of one character must be violated in order to achieve consistent spacing in a single word. This invasion is known as kerning and is considered acceptable behavior between two characters.

Word*i*spacing

Interword spacing is specified in terms of
loose, normal, tight. The amount of space
between words should be proportional
to the size of the letters used.

Traditionally, normal word spacing
has the width of an i.

Interword spacing iis the space between words.
Like tracking, interword spacing is adjusted
uniformly within a sentence, paragraph or larger
block of text.

Traditionally, loose interword spacing
has the width of an o.

Interword spacing is the space between
words. Like tracking, interword spacing is
adjusted uniformly within a sentence,
paragraph or larger block of text.

Interword spacing is the space between words. Like
tracking, interword spacing is adjusted uniformly within
a sentence, paragraph or larger block of text. Certain
procedures also apply to keeping words properly distanced.

Leading

In moveable typesetting, interline spacing was adjusted by inserting strips of lead between lines of type.

This block of text is set with 12 point type, over 6 points of lead. The extra space, or lead, is indicated in blue. Type is set solid when no points of lead are added between lines.

In metal typesetting, interline spacing was adjusted by inserting strips of lead between lines of type. In digital typesetting, the term "leading" is used to describe the vertical distance between sequential baselines of type.

In computer typesetting, the leading value is the sum of the point size of the type used and the amount of space added between baselines. This text block uses 12 point type, with 6 points of lead, and is specified as "12 (point type) over 18 (point leading)," or 12/18.

In metal typesetting, interline spacing was adjusted by inserting strips of lead between lines of type. In digital typesetting, the term "leading" is used to describe the vertical distance between sequential baselines of type.

This line of text is set with 12 point type, over -6 points of lead. Type has negative interline spacing when the line space is less than the point size of the type used.

In metal typesetting, interline spacing was adjusted by inserting strips of lead between lines of type. In digital typesetting, the term "leading" is used to describe the vertical distance between sequential baselines of type.

Interline spacing is commonly referred to as leading, which is a term that originated with cast metal typesetting.

Measure

The measure contains the line length, which is determined by the sum of the set widths of all the characters and spaces in a single line of type. Line length is measured in picas.

8 point type

abcdefghijklmnopqrstuvwxyzabcdefghijklm
abcdefghijklmnopqrstuvwxyzabcdefghijklm

10 point type

abcdefghijklmnopqrstuvwxyzabcdefghijklm
abcdefghijklmnopqrstuvwxyzabcdefghijklm

12 point type

abcdefghijklmnopqrstuvwxyzabcdefghijklm
abcdefghijklmnopqrstuvwxyzabcdefghijklm

picas 0 1 2 3 4 5 6 7 8 9 10 11 12 13 14 15 16 17 18 19 20 21 22 23

An appropriate line length is 40 characters of regular width type, which equals approximately 1.5 alphabets. Short lines are 8–12 picas in length, composed of small or condensed type. Long lines are 24–30 picas in length, composed of 12–14 point type.

Traditionally, characters are arranged in horizontal strings to form words. Words are arranged to form sentences. Sentences are linked into what is called continuous text matter. The MEASURE is a horizontal space that contains text and determines line length. Measures stacked on top of one another create COLUMNS.

left alignment (flush left, rag right)
Also known as quad left, this alignment refers to a line of text pushed to the left side of a column or margin. Lines of text break unevenly on the right side of the text block, according to the width of the measure, and produce what is called a rag. Word spacing is regular as a result.

Warning! A gridless counterculture is stampeding through the lifeblood of communication with wild west energy and an outlaw mentality that does little more than draw attention to its stylized, superficial self. What is new today will prove to be a mere flash of a pixel tomorrow. These renegade types like to smash together in an almost ritualistic demonstration of disregard towards order and clarity.

right alignment (flush right, rag left)
Also known as quad right, this alignment refers to a line of text pushed to the right side of a column or margin. Lines of text break unevenly on the left side of the text block, according to the width of the measure, and produce what is called a rag. Word spacing is regular as a result.

Warning! A gridless counterculture is stampeding through the lifeblood of communication with wild west energy and an outlaw mentality that does little more than draw attention to its stylized, superficial self. What is new today will prove to be a mere flash of a pixel tomorrow. These renegade types like to smash together in an almost ritualistic demonstration of disregard towards order and clarity.

justified
Lines of text aligned on both the left and the right is known as justified. As a result, word spacing is uneven in order to force the entire line to fill the width of the measure.

Warning! A gridless counterculture is stampeding through the lifeblood of communication with wild west energy and an outlaw mentality that does little more than draw attention to its stylized, superficial self. What is new today will prove to be a mere flash of a pixel tomorrow. These renegade types like to smash together in an almost ritualistic demonstration of disregard towards order and clarity.

We receive the rehabilitated text block from the Forensics Lab, in several different ALIGNMENTS. Its content is a chilling message...

centered
Also known as quad center, this
alignment places an equal amount of
space on both sides of a line of text in
order to center it in a measure.

Warning! A gridless counterculture is stampeding through the
lifeblood of communication with wild west energy and an
outlaw mentality that does little more than draw attention to its
stylized, superficial self. What is new today will prove to be
a mere flash of a pixel tomorrow. These renegade types like
to smash together in an almost ritualistic demonstration
of disregard towards order and clarity.

asymmetrical
This alignment has no specific result.
Text can be arranged in an asymmetrical
manner to break lines into smaller units
and give an overall appearance that may
or may not relate to its message.

Warning!

A gridless
counterculture
is
stampeding
through the lifeblood of communication
with
wild west energy
and an
outlaw mentality
that does little more than draw attention to its
stylized, superficial self.
What is new today will prove to be
a mere
flash of a pixel tomorrow.
These renegade types like to
smash together
in an almost
ritualistic demonstration
of
disregard
towards
order
and
clarity.

READABILITY

Readability

The past 550 years of printing has revealed some conclusions on legibility. For example, a roman typeface is more legible than its other styles such as italic, all capitals and condensed.

roman

italic

ALL CAPITALS

Read me! I am a line of serifed text.

Read me! I am a line of sans serif text.

Typefaces with serifs are considered to be more legible than sans serif typefaces. Serifs aid in distinguishing letters from one another, and they force letters to stay a set distance apart. The orientation of serifs also facilitate a horizontal, left-to-right, reading direction.

Readme!Iamalineofsquishedsansseriftext.

READABILITY is another dangerous term that is traditionally measured by the degree of clarity and ease with which a collection of characters can be read. Readability depends on legibility, but involves more complex—nonphysical—attributes. The form and behavior a character assumes, and the manner in which characters interact with one another, contribute to the readability of a message.

rivers

Because justified text attempts to fill the entire designated measure, it must produce irregular word spacing. Rivers are the unfortunate result of a combination of loose word spacing and short line lengths in a block of justified text. Beware the rushing waters!

Warning! A gridless counterculture is stampeding through the lifeblood of communication with wild west energy and an outlaw mentality that does little more than draw attention to its stylized, superficial self. What is new today, will prove to be little more than the flash of a pixel tomorrow. These renegade types like to smash together in an almost ritualistic demonstration of disregard towards order and clarity.

rags

Rag is the pattern formed by line breaks in a block of text.

A good rag should appear like the edge of a torn piece of paper. Each line of text should break in a different place.

Warning! A gridless counterculture is stampeding through the lifeblood of communication with wild west energy and an outlaw mentality that does little more than draw attention to its stylized, superficial self. What is new today, will prove to be little more than the flash of a pixel tomorrow. These renegade types like to smash together in an almost ritualistic demonstration of disregard towards order and clarity.

— good rag

A bad rag is the result of line breaks that form general concave, convex or angular shapes

Warning! A gridless counterculture is stampeding through the lifeblood of communication with wild west energy and an outlaw mentality that does little more than draw attention to its stylized, superficial self. What is new today, will prove to be little more than the flash of a pixel tomorrow. These renegade types like to smash together in an almost ritualistic demonstration of disregard towards order and clarity.

— bad rag

widows

A widow is a single word at the end of a paragraph that sits all by itself on a single line. One should never trust a smiling widow.

widow

orphans

An orphan is a single word, or short line, at the end of a paragraph that is pushed to the top of the next column or page and sits all by itself on a single line. This unfortunate situation must be avoided at

all costs.

orphan

There are several clues to look for when stamping out typographic crime. If found, immediate action is required under the typographic penal code, a.k.a. Rules of Thumb.

The surroundings within this hideaway for the tragically hip
suddenly assemble an eerie familiarity. I am confronted with
the feeling that I have been here before. Was it a nightmare
I hoped to forget? Was it my previous life? I know that styles
change as frequently as the setting sun in this digital age.
Perhaps it was with my previous partner? Then it hits me...

Some time ago, when I was a rookie like Dingbat, ISO sent my
then partner, whom I will call "Qwerty," undercover to
investigate the actions of a group of rogue characters involved
in an anti-capitalization ring. This gang of characters believed
that there was no room in this world for capital letters and
set out on a path of fervent destruction.

Like me, my partner was a perfectionist and a utilitarian at
heart. Nothing could bend his stroke. I understand the
sacrifices one must make to go under cover, but Qwerty was
right for the job. Then, deep into the investigation, something
happened. Many say he simply succumbed to the pressure of
this line of investigative work. I believe he got too close to
the job and saw too many details to keep in order.

The grid

The traditional typographic grid is made of modules, columns, margins, column intervals, and flowlines.

module
The module is the building block of the typographic grid. It is established by dividing the page frame into units and then grouping these units into modules.

unit

To make a long story short, Qwerty ended up digitizing himself and affiliating with some questionable characters. Sometimes I would see him in this neighborhood, mumbling of the apocalypse...being imprisoned by the grid for eternity... succumbing to the hierarchies dictated by scale and placement.
The GRID is thought of as a sanctuary of well organized, uniform characters. It is a framework constructed of crisscrossing and parallel lines that allows consistent alignment and positioning of characters in blocks of continuous text.

column
The column is the region of the grid that contains printed text. It is a horizontal zone made of stacked measures.

column interval
The interval of space separating two or more columns is known as the column interval. Traditionally, the column interval is equal to the leading value of the text placed in the columns it separates.

margin
The region defining the outer perimeter of
the typographic grid is known as the margin.
Traditionally, text is not printed in this area.

gutter
The gutter is the margin area that is located
at the intersection of two bound pages. It is
a dangerous area that must be avoided!

Yeah, Qwerty eventually solved the anti-capitalization case.
The perps were convicted and sent to serve time behind the
bars of a UPC code penitentiary up north...

Qwerty was great at putting away characters who chose to
exist in the margins of communication. He was responsible
for restoring an orderly grid to society. But this grid, the
very device my former partner spent a successful career
protecting, became an object that failed to contain a world
overloaded with information.

flowline
The flowline is a horizontal line that aids in aligning text blocks in a grid in a consistent, horizontal manner.

What eventually happened to Qwerty? His form was never the same after his digitization. And this began to effect his work. ISO headquarters eventually gave him a new identity under the witness protection program and sent him into a more transparent existence. I have not seen Qwerty since...

"What dark forces are among us? It seems we...."

Dingbat's words are suddenly cut off by...

"Sir, the grid is breaking up! we're

a page-trembling thump, punctuated by...

...a sickening splat that sends us spiralling into the vortex of...

continued.

Typographic Genealogy

type family
A type family includes all the variations relating to a basic type design. A type family is composed of typefaces:

Helvetica

Helvetica Compressed

Helvetica Condensed

Helvetica Inserat

Helvetica Narrow

Helvetica Neue

Helvetica International

typeface
Technically, the typeface refers to a specific unified design of a set of characters and includes all the various styles such as upper and lowercase; italic and bold. Several typefaces may be included in a single type family. A typeface may be composed of several font sets:

Helvetica Condensed Light

Helvetica Condensed Light Oblique

Helvetica Condensed Regular

Helvetica Condensed Regular Oblique

Helvetica Condensed Bold

Helvetica Condensed Bold Oblique

Helvetica Condensed Black

Helvetica Condensed Black Oblique

font
Derived from the Old French *fondre,* as "to melt or pour forth," this term originated with cast metal type. The font once referred to a set of characters of the same typeface design, style and size. A font is now considered a set of characters, including alphabetic, numeric and analphabetic, of the same typeface design and style but with alterable sizes. Additional font sets for a single typeface may include such characters as small caps, ligatures, science and math, and other unique typographic symbols. These specialized sets are commonly referred to as expert sets.

Every typographic character belongs to a larger family whose members possess uniform visual traits. Typographic GENEALOGY is a complex science that evolved with the past 550 years of printing. The terminology associated with this study: TYPEFACE, TYPE FAMILY, FONT, TYPE STYLE, are often used synonymously which only adds confusion to rookies like Dingbat.

instruction	mark in margin	mark in text	corrected type
period	⊙	This is a difficult case	This is a difficult case.
comma	⌃	letter word sentence	letter, word, sentence
hyphen	⹀	18 point character	18-point character
colon	⦂	Episode One The Crime Scene	Episode One: The Crime Scene
semicolon	⌃	Collect the evidence solve the case.	Collect the evidence; solve the case.
apostrophe	⌄	Inspector Fleurons partner	Inspector Fleuron's partner
double quotation marks	⌄/⌄	this shady character	this "shady" character
single quotation marks	⌄/⌄	"this shady character"	this "'shady' character"
en dash	⊥N	1450 present	1450–present
em dash	⊥M	This character a shady sort is one of the 10 most wanted.	This character—a shady sort—is one of the 10 most wanted.
virgule (slash)	/	this nice/mean character	this nice/mean character
three ellipses	\|⊙\|⊙\|⊙\|	this character	this...character
four ellipses	⌢⊙\|⊙\|⊙\|⊙\|	this character	this character....
upper case	uc	this shady character	This SHADY character
lower case	lc	This Shady Character	this shady character
small capitals	sc	this shady character	this SHADY character
italic	ital	this shady character	this *shady* character
roman	rom	this *shady character*	this shady character
boldface	bf	this shady character	this **shady** character
lightface	lf	**this shady character**	this shady character
superior (superscript)	⌄	this shady character1	this shady character[1]
inferior (subscript)	⌃	this shady character2	this shady character$_2$

Proofreaders' Marks

These simple marks are used by humans when they take typographic law into their own hands.
They are used to signal others that something is wrong and must be corrected.

instruction	mark in margin	mark in text	corrected type
Delete	℘	the mean character	the character
Delete, close up space	℘	the characacter	the character
Insert	shady	the character	the shady character
Let it stand	stet	the shady character	the shady character
Spell out	sp	②characters	two characters
Transpose	tr	the character shady	the shady character
Move left	☐	☐ the character	the character
Move right	☐	the character	the character
Move up	☐	the character	the character
Move down	☐	the character	the character
Align	‖	the shady character / the hapless victim	the shady character / the hapless victim
Straighten line	―	the character	the character
Insert space	#	thecharacter	the character
Equalize space	eq#	the shady character	the shady character
Close up	◠	the char acter	the character
en space	1/N	the character	the character
em space	1/M	the character	the character
Run in	run in	This is a case of formal foul play.	This is a case of formal foul play.
New paragraph	¶	"What is this?" "It is a serif, Dingbat!"	"What is this?" "It is a serif, Dingbat!"
Flush paragraph	¶	"What is this?" "It is a serif, Dingbat!"	"What is this?" "It is a serif, Dingbat!"

type style
The type style refers to the variations of the
same character in the same typeface. For
example: upper/ lower case; roman/italic;
regular/bold; small caps. A character may
possess any combination of styles: roman
lower case; bold lower case; bold small
caps; bold italic, and so on.

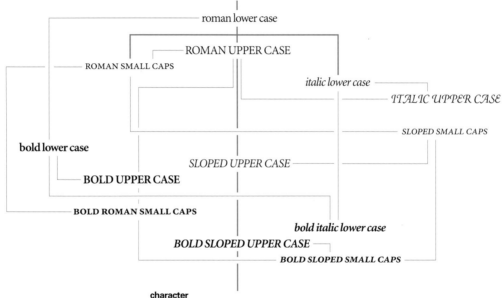

roman lower case

ROMAN UPPER CASE

ROMAN SMALL CAPS

italic lower case

ITALIC UPPER CASE

SLOPED SMALL CAPS

bold lower case

SLOPED UPPER CASE

BOLD UPPER CASE

BOLD ROMAN SMALL CAPS

bold italic lower case

BOLD SLOPED UPPER CASE

BOLD SLOPED SMALL CAPS

character
A character is an individual symbol, be it a
letter, numeral, punctuation mark, accent
mark, pictogram, ideogram. Elements such
as spaces, tabs, and returns created with a
computer are also considered characters,
with a size specific to the typeface. Three
general categories include: alphabetic, or
letters; numeric, or figures; and analphabetic
symbols which includes accents,
punctuations, ideograms, and pictograms.

alphabetic **numeric** **analphabetic**

The Standard & Expert Font Set

lower case
Also known as minuscules.

abcdefghijklmnopqrstuvwxyz

upper case
Also known as majuscules, or capitals.

ABCDEFGHIJKLMNOPQRSTUVWXYZ

small capitals
Capital letters that match the
x-height of lower case letters.

ABCDEFGHIJKLMNOPQRSTUVWXYZ

text (non-aligning) figures
Numerals that match the height of lower
case letters. Found in expert font sets.

1234567890

titling (aligning) figures
Numerals that match the height of upper
case letters. May be slightly smaller than
upper case letters. Also known as lining
figures as they share the same baseline.

1234567890

superscript (superior)
Characters that levitate above the baseline.
subscript (inferior)
Characters that sit below the baseline.

1234567890 superscript

subscript 1234567890

ABCDE

fractions
Independent characters usually included
in expert font sets. If fractions are not
available as pre-designed characters, they
must be created with whatever parts can
be scraped together.

¼ ½ ¾ ⅛ ⅜ ⅝ ⅞ ⅓ ⅔ real fractions

1/4 1/2 3/4 1/8 3/8... fake (level) fractions

A well developed TYPEFACE in a TYPE FAMILY consists of a
STANDARD set of characters in addition to the alphabet. The
standard collection of characters is known as a FONT SET.

Not every font set will have a full set of characters. In many
cases, two or more separate font sets may be required to
form a complete set of characters in a single typeface. Font
sets in addition to the standard set are known as EXPERT
FONT sets, as they usually contain specialized characters.

accent symbols

symbol & name	keystroke
´ acute	Oe/X
Á acute, cap A	SOy
Í acute, cap I	SOs
Ó acute, cap O	SOh
Ú acute, cap U	SO;
˘ breve	SO.
ˇ carib (caron)	SOt
Ç cedilla, cap	SOc
ç cedilla, l/c	Oc
^ circumflex	Oi/X
Â circumflex, cap A	SOm
Î circumflex, cap I	SOd
Ô circumflex, cap O	SOj
Ø danish cap O	SOo
¨ diaeresis/umlaut	Ou/X
Ï diaeresis, cap I	SOf
˙ dot accent (overdot)	Oh
` grave	O`/X
Ò grave, cap O	SOl
˝ hungarian umlaut	SOg
˛ ogonek	SOx
ª ordfeminine	O9
º ordmasculine	O0
° volle (ring)	Ok
Å swedish cap A	SOa
å swedish l/c a	Oa
˜ tilde	On/X

numeric & mathematical symbols

symbol & name	keystroke		
≈ approximately equal	Ox		
· decimal (midpoint dot)	SO9		
° degree	SO8		
÷ division	O/		
= equals	=		
/ solidus (fraction bar)	SO1		
> greater than	>		
≥ greater than or equal	O.		
∞ infinity	O5		
∫ integral	Ob		
< less than	<		
≤ less than or equal	O,		
¬ logical not (negation)	Ol		
◊ lozenge	SOv		
¯ macron	SO,		
- minus	-		
≠ not equal to	O=		
# octothorp (hash)	#		
∂ partial differential	Od		
% per cent	%		
π pi	Op		
+ plus	+		
± plus or minus	SO=		
" prime, double	"		
' prime, single	'		
∏ product	SOp		
√ radical	Ov		
/ virgule	/		
Σ summation	Ow		
~ swung dash	~		
	vertical bar		

currency symbols

symbol & name	keystroke
¤ international currency	SO2
ƒ guilder	Of
£ sterling	O3
¥ yen	Oy
$ dollar	$
¢ cent	O4

pictographic symbols

symbol	key
apple	SOk
* asterisk	*
† dagger	Ot
‡ double dagger	SO7

The Standard ISO Keyboard Character Set

character set standards

ISO LATIN
(International Standards Organization)
Many characters are accessible through
a standard computer keyboard,
regardless of the font used, thanks to
ASCII, the international arm of the ISO.
Some of the more specialized characters
may be accessed though a specific
"expert" font set of a particular typeface.

ASCII
(American Standard Code for Information
Interchange) This is the code system for
converting alphanumeric characters into
computer readable codes. It is limited to 128
characters, but covers up to 256 separate
characters in its extended (ANSI) form.

ANSI
(The American National Standards Institute)
This character set includes a total of 256
characters (the first 128 are ASCII).

Expert
Not a set standard, but one that includes
specialized characters such as small caps,
oldstyle figures, ligatures, and other
miscellaneous characters. Also known as
SCOSF (small caps, oldstyle figures). Some
expert characters replace similar characters
found in the standard ISO keyboard set.

keystroke symbols

S = Shift key
O = Option key
SO = Shift + Option keys
/X = A second keystroke, usually a vowel
to complete an accent use.

analphabetic symbols

symbol & name	keystroke
& ampersand	&
\ backslash	\
{ brace, open	{
} brace, close	}
• bullet	**O**8
^ caret	^
: colon	:
… ellipsis	**O**;
— em rule (em dash)	**SO**-
– en rule (en dash)	**O**-
! exclamation	!
« guillemot, open double	**O**\
» guillemot, close double	**SO**\
‹ guillemot, open single	**SO**3
› guillemot, close single	**SO**4
- hyphen	-
(parentheses, open	(
) parentheses, close)
. period	.
\| pipe	\|
? query (question mark)	?
" quote, open double	**O**[
" quote, close double	**SO**[
' quote, open single (open apostrophe)	**O**]
' quote, close single (close apostrophe)	**SO**]
„ quote, double baseline	**SO**w
‚ quote, single baseline	**SO**0
; semicolon	;
¡ spanish exclamation	**O**1
¿ spanish query	**SO**/
[square bracket, open	[
] square bracket, close]
_ underline	**S**-

alphabetic symbols

symbol & name	keystroke
@ "at"	@
© copyright	**O**g
Δ delta	**O**j
Œ diphthong (ethel), cap OE	**SO**q
œ diphthong (ethel), l/c oe	**O**q
Æ diphthong (aesc)	**SO**'
æ diphthong (aesc)	**O**'
ı dotless i	**SO**b
ß eszett	**O**s
ƒ florin	**O**f
fi ligature, fi	**SO**5
fl ligature, fl	**SO**6
μ mu	**O**m
Ω omega	**O**z
¶ paragraph	**O**7
® registered	**O**r
§ section	**O**6
™ trademark	**O**2

ligatures
Created from the union of two or three characters into a single character, to eliminate awkward overlaps of the lower case letters f, l and i.

ff fi ffi ffl no ligatures

ff fi fl ffi ffl ligatures

diphthongs
A ligature that creates a complex speech sound, beginning with the first vowel and ending with the second.

OE oe AE ae no diphthongs

Œ œ Æ æ diphthongs

SS no eszett

ß eszett

eszett
The eszett is a ligature composed of the long s + short s sounds.

accents (diacritics)

Á É Í Ó Ú á é í ó ú

Â Ê Î Ô Û â ê î ô û

Ä Ë Ï Ö Ü Ÿ ä ë ï ö ü ÿ

À È Ì Ò Ù à è ì ò ù

Ã Ñ Õ ã ñ õ

punctuation

. , ; : ! ? " " ' ' ' " ^ [] { } < > () - – —

currency symbols

¤ $ £ ¥ ¢

mathematical symbols

≈ ÷ = > ≥ < ≤ ∞ ≠ π √ ∑

pictograms, ideograms, and other alphabetic symbols
A pictogram is a character that represents a concrete object.
An ideogram is a character that represents a complex or abstract idea.

 * † ‡

& @ © ¶ ® § ™

This document was originally classified and could not have
been released to the public without the influence of the
following humans: Brian Morris, Angie Patchell, Natalia Price-
Cabrera, Norman Turpin, Simon Hennessey and Ray Potts,
all at RotoVision, SA; friends and colleagues in the Department
of Communication Arts and Design, School of the Arts, at
Virginia Commonwealth University. Many thanks to the above
for helping to expose what really goes on beneath the surface
of a seemingly benign typographic world...